Hound for the Holidays

A Bark & Smile® Book

BY KIM LEVIN AND JOHN O'NEILL

**Andrews McMeel
Publishing, LLC**

Kansas City

09 TWP 10 9 8 7 6 5

ISBN-13: 978-0-7407-5567-5

ISBN-10: 0-7407-5567-6

Library of Congress Control Number: 2005923392

www.barkandsmile.com

To Charlie, the best hound around.

ACKNOWLEDGMENTS

Thank you to all of the hounds that appear in *Hound for the Holidays*. This book would not be possible without you.

Thanks to Dorothy O'Brien and the wonderful team at Andrews McMeel Publishing. We are happy that we have had such a long partnership with you. We'd also like to thank Jim Hutchison for his printing prowess. And lastly, to our favorite hound Charlie, thank you for your love and loyalty.

Happy Holidays!
K.L. and J.O.

This holiday season,
let's remember the things
that really matter.

\mathscr{F}amily reunions

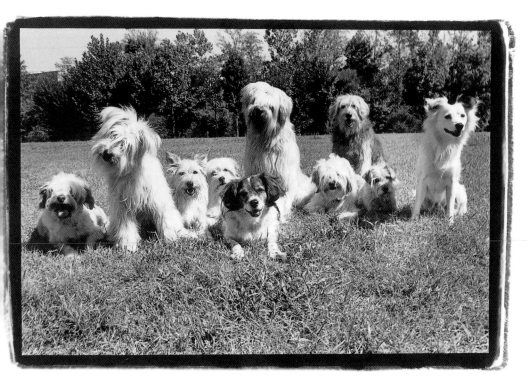

Fireside chats

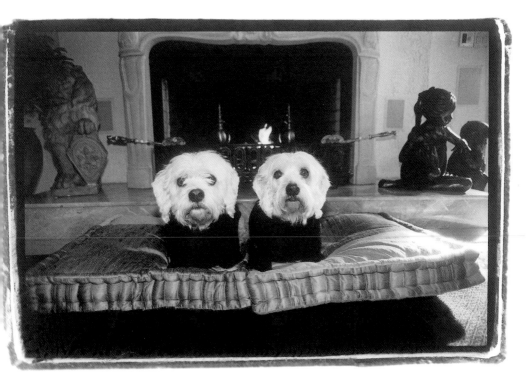

The Thanksgiving nap

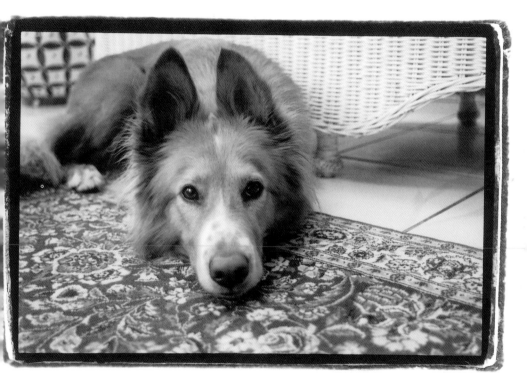

Frosty mornings

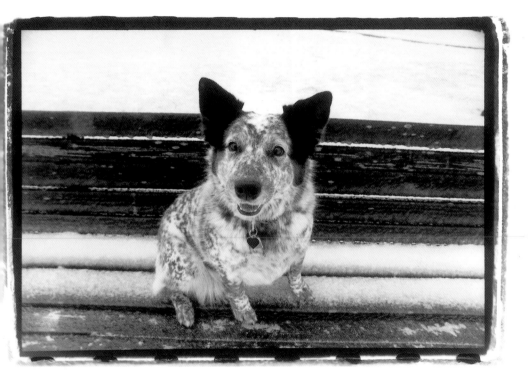

Winter breezes

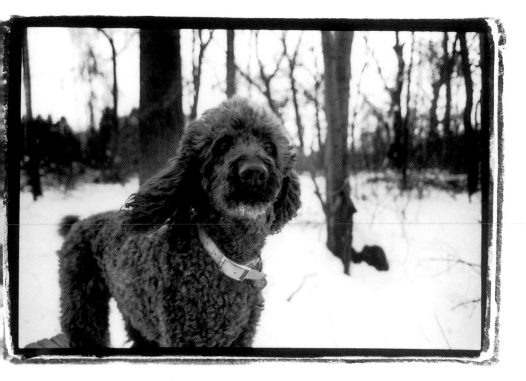

\mathcal{F}resh snow . . .

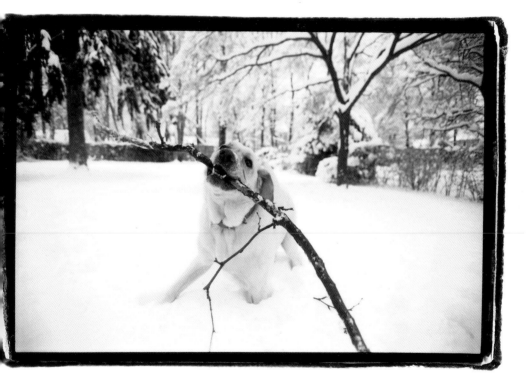

\mathcal{A}nd discovering it
for the first time

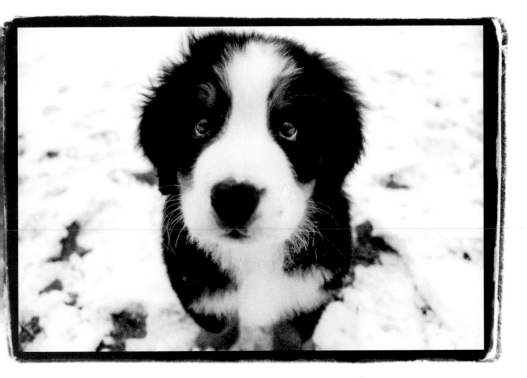

A trip to the big city

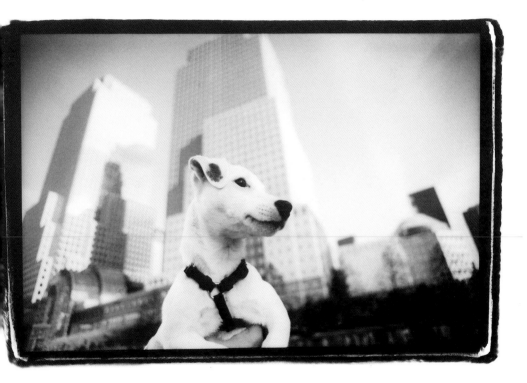

Window shopping

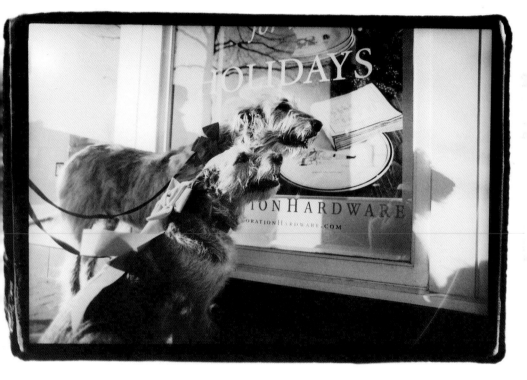

Thick sweaters

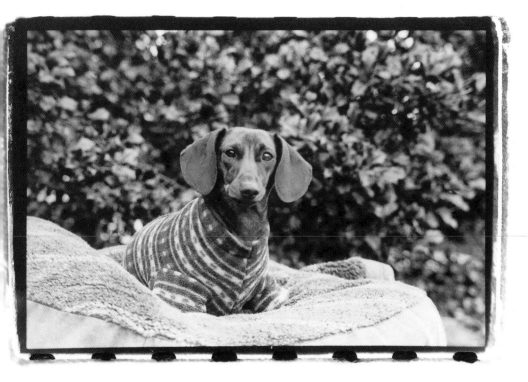

Long scarves

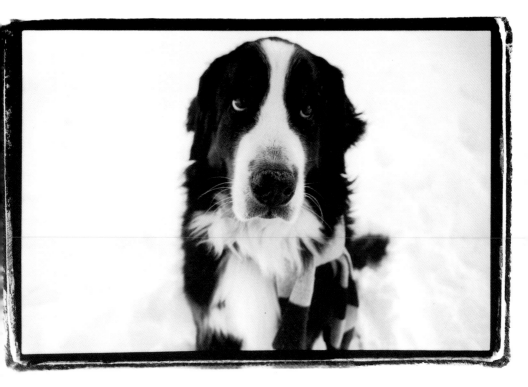

Warm mittens

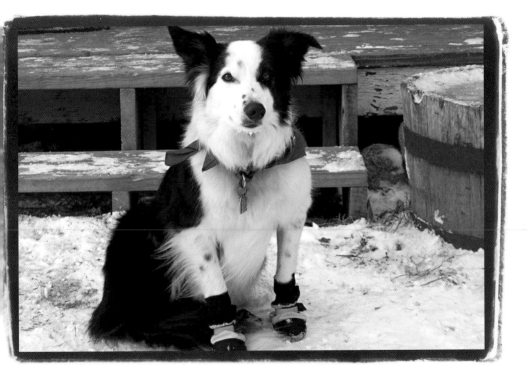

Once-a-year couture

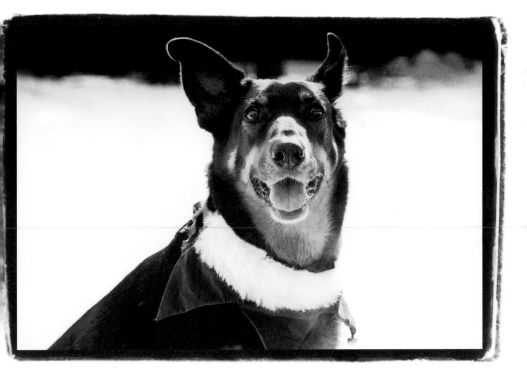

A little neighborhood caroling

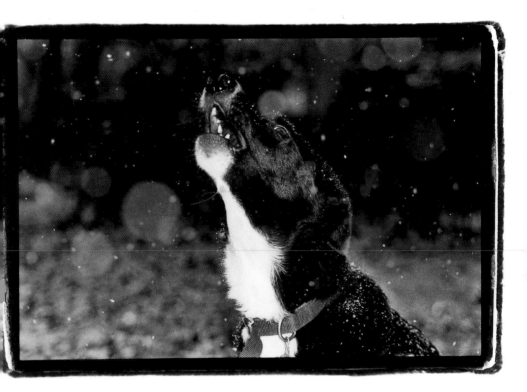

Trimmed trees

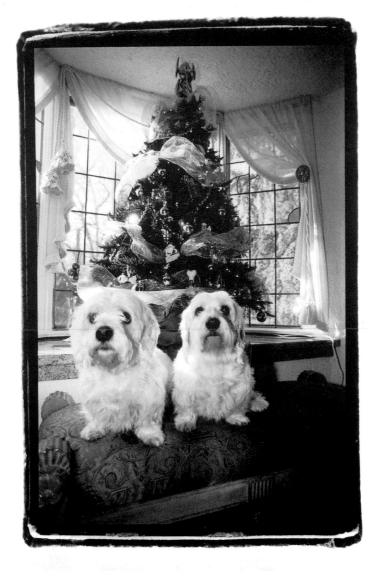

Welcoming wreaths

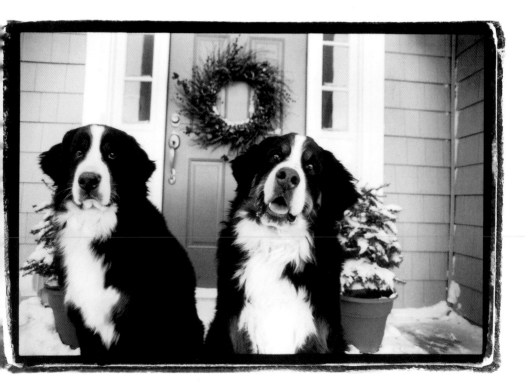

*Y*our presence,
not your presents

38

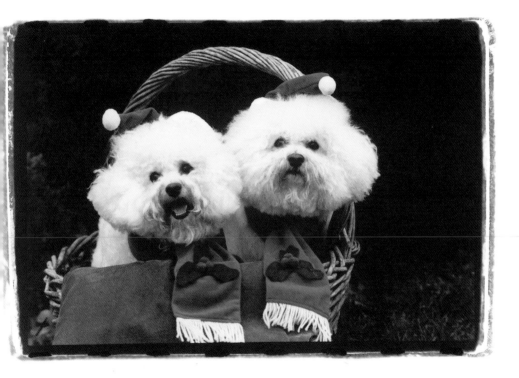

Winter jaunts

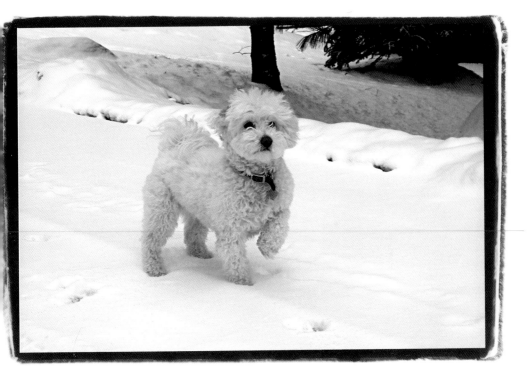

*C*atching snowflakes on
your tongue . . .

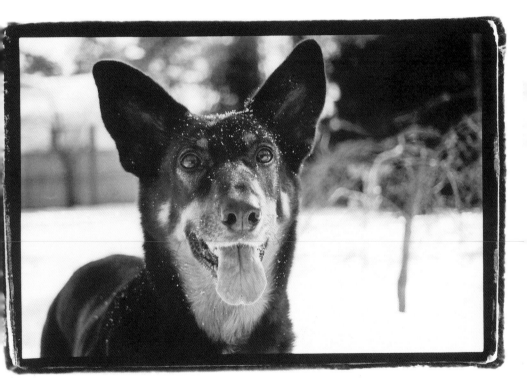

Or on your nose

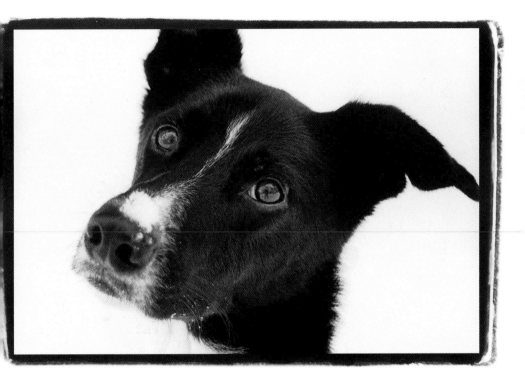

\mathcal{B}ody heat

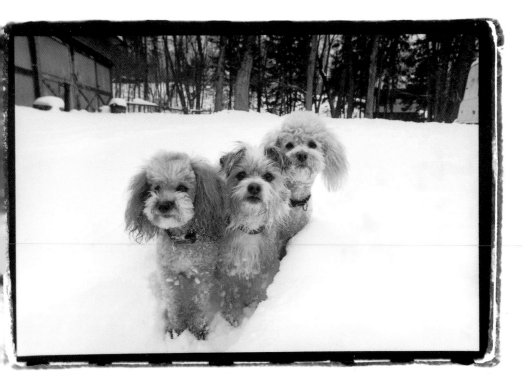

\mathscr{F}rozen ponds

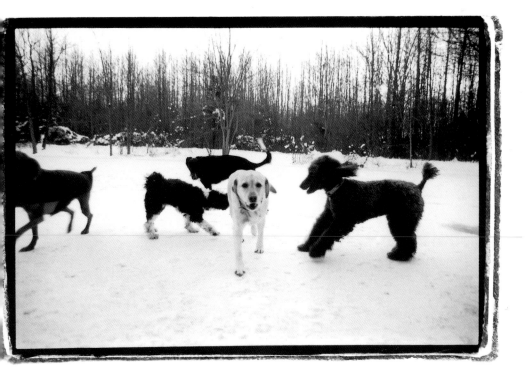

Buried treasure

50

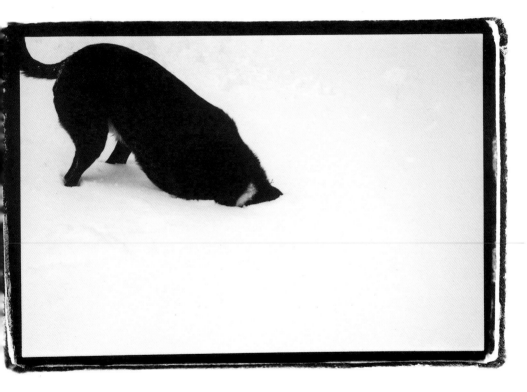

Old-fashioned sleigh rides

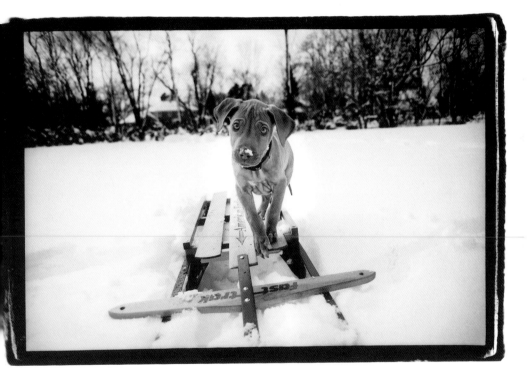

Well-played

snowball fights

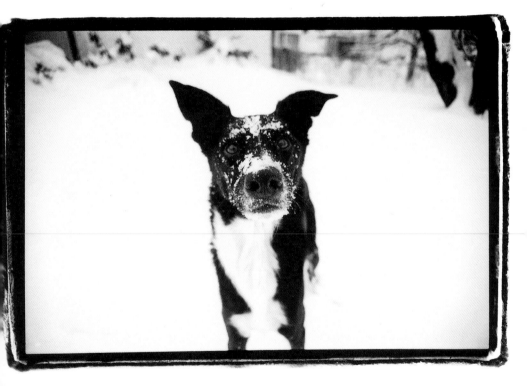

The last sip
of hot chocolate

56

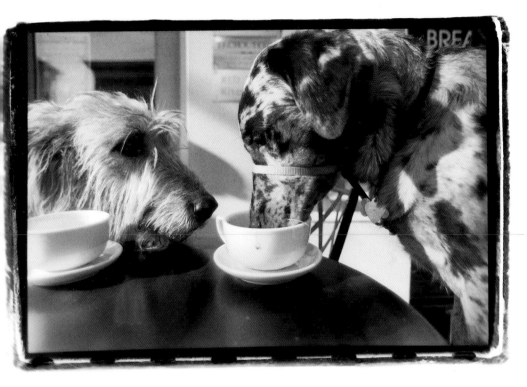

\mathcal{S}low work days

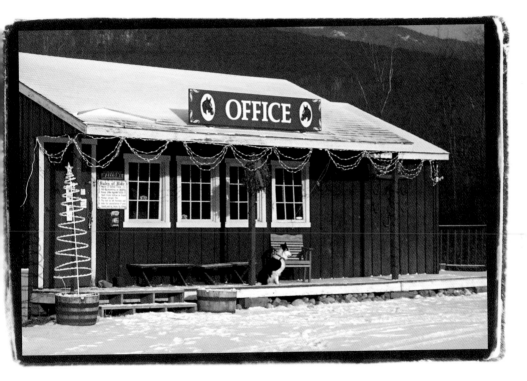

\mathcal{S}anta's lap

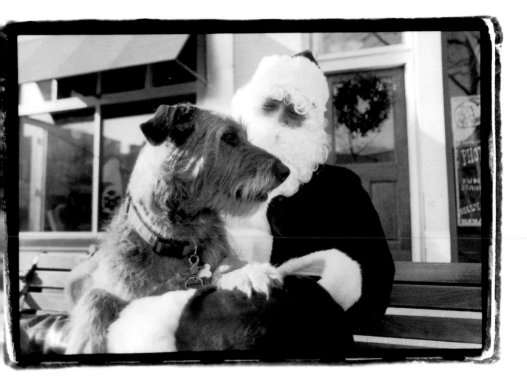

Heading to grandma's house

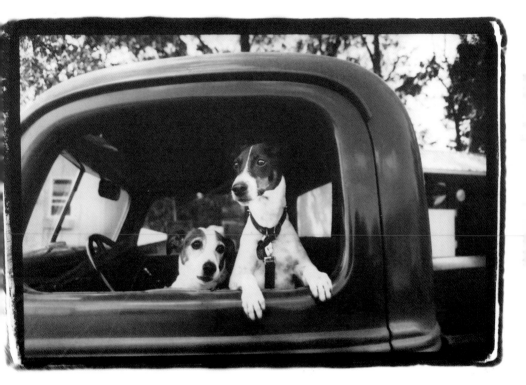

Catching up

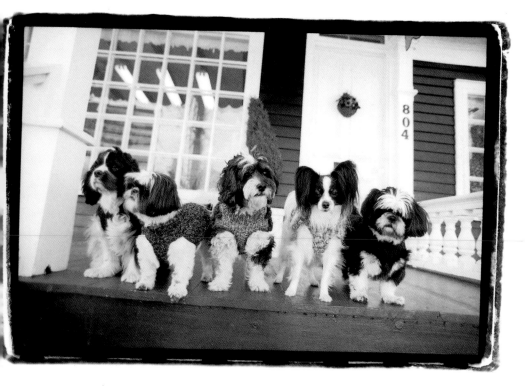

\mathcal{I}ndulging guilt-free

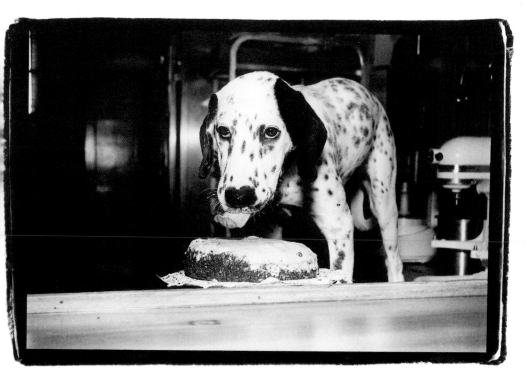

\mathcal{S}nowmen and candy canes

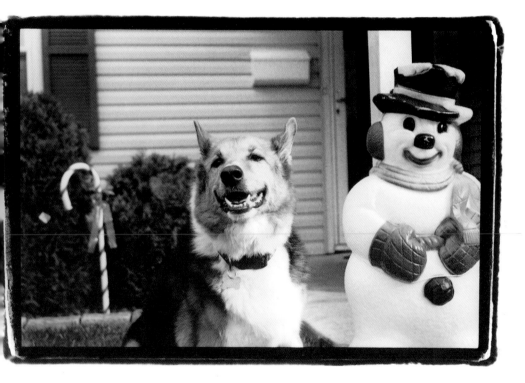

Big red bows

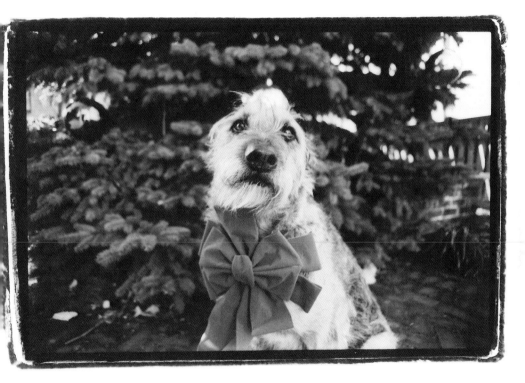

Stuffed stockings

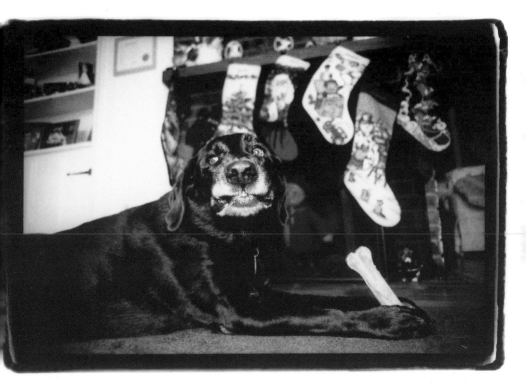

New toys

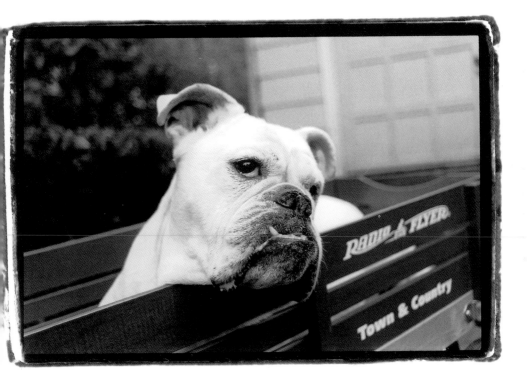

The Christmas spirit

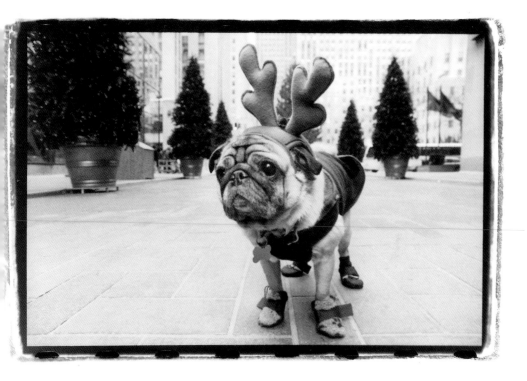

\mathcal{A} toast to the new year

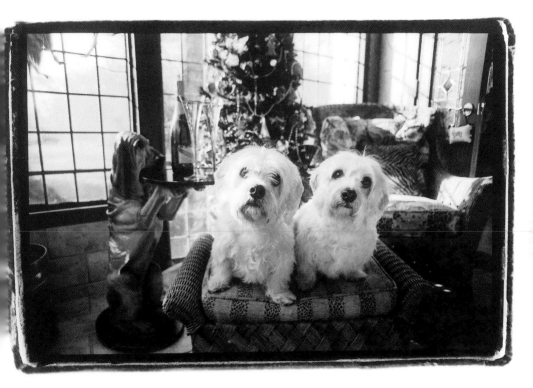

Other Books by Kim Levin

Growing Up (with John O'Neill)
Dogma (with Erica Salmon)
Why We Love Cats
Why We Love Dogs
Why We Really Love Dogs
Dogs Are Funny
Dogs Love . . .

*Working Dogs: Tales from Animal
Planet's K-9 to 5 World*
Cattitude (with Christine Montaquila)
Erin Go Bark (with John O'Neill)
For the Love You Give (with John O'Neill)